MIRŌ'S STUDIO

© 2004 Assouline Publishing for the present edition
601 West 26ᵗʰ Street, 18ᵗʰ floor
New York, NY 10001, USA
Tel.: 212 989-6810 Fax: 212 647-0005
www.assouline.com

First published in Great Britain in 1996
by Thames and Hudson, Ltd, London.
Copyright © 1996 Éditions Assouline, Paris.
© Adagp, Paris 1996, for works by Joan Miró.
© Fundació Miró for the text by Joan Miró as well
as for the photographs of works by Joan Miró.
© Jean-Marie del Moral for the photographs
of Joan Miró and his studio.

Translated from the French by Caroline Beamish

Printed by Grafiche Milani (Italy)

ISBN: 2 84323 625 8

MIRŌ'S STUDIO

TEXT BY JOAN PUNYET MIRO
PHOTOGRAPHS BY JEAN-MARIE DEL MORAL

ASSOULINE

I shall never forget Miró

I can still see Barcelona as it was then, in 1978. Franco had gone and there was a breath of freedom blowing across the city.

I knew very little about Miró at the time. I was eager mainly to get to know Barcelona; the weather was so beautiful that wonderful spring.

My parents were Republican exiles and a magazine had sent me to Spain to take photographs of various intellectuals. I had been hearing about a group of young actors, 'La Claca', and their show Mori el Merma, *which was about to have its first performance at the Gran Teatro del Liceo. Miró had designed the scenery and costumes. The story was a free adaptation of* Ubu Roi, *and the grotesque hero was none other than Franco himself. The energy of the actors was admirably in tune with Miró's visual poetics – his flamboyant reds, brilliant yellows and supernal blues.*

I can still hear the tremendous applause when the performance ended. I was transfixed and, like most of the standing audience, in tears, overwhelmed by the joy of exorcizing forty years of oppression. I can still see Miró, small, frail and wonderful, appearing suddenly on the stage to acknowledge the ovation, which then doubled in volume.

A few days later I had the privilege of being allowed to take photographs inside the limpid white studio in Palma, Majorca. All was quiet. In spite of the heat outside, a few friendly snatches of birdsong slipped in to salute the peace and serenity of the premises.

I was unaware then that Miró had started dreaming of this vast studio in Paris in 1938, at a time when solitude and poverty never quite managed to dull his optimism. 'My dream, when I am in a position to settle down somewhere, is to have a very large studio ... so that I can have space, lots of canvases ... I would like to try my hand at sculpture, pottery, engraving, have a press.'

Years later the objects he had picked up when he was out walking, or that friends had sent him, or that he had bought in markets in odd parts of the world, had all found their place; in the calm of the studio each glowed with the contained energy of an arrow about to be shot from a bow.

Miró's arrows are still in the air above us, very high up, eternally pursuing their way overhead, straddled by stars in the infinite depths of the great blue skies.

Jean-Marie del Moral

'I Dream of a Large Studio'

When I arrived in Paris in March 1919, I stayed on rue Notre-Dame des Victoires in the Hôtel de la Victoire. I remained in Paris all through the winter and then in the summer went back to Spain, to the countryside. The following winter I came back to Paris and stayed at another hotel, at 32 boulevard Pasteur. It was there that I received a visit from Paul Rosenberg. Picasso and Maurice Raynal had spoken to him about me. Soon afterwards Pablo Gargallo, who was spending the winter in Barcelona where he was professor of sculpture at the School of Fine Arts, gave me his studio at 45 rue Blomet, next to the Bal Nègre, which was still unknown to Parisians at that time and would only later be 'discovered' by Robert Desnos. André Masson was in the next studio, we were only separated by a partition. It was on rue Blomet I began to work. I painted the *Head of a Spanish Dancer*, which belongs to Picasso, *Table with Glove*, etc. It was a very tough period; the windows were broken, and my stove, which had cost forty-five francs at the flea market, didn't work. But the studio was very clean. I did the housework myself. Being very poor, I could only afford one lunch a week: the other days I had to settle for dried figs and chewing gum.

The following year I wasn't able to get Gargallo's studio again. First I stayed at a small hotel on boulevard Raspail, where I finished *The Farmer's Wife*, *Ear of Grain* and other pictures. I then left the hotel for a furnished room on rue Berthollet. *The Carbide Lamp*. Summer in the country. Return to Paris and the studio on Blomet. I finished *The Farm*, which I had started in Montroig and continued in Barcelona. Léonce Rosenberg, Kahnweiler, Jacques Doucet, all the Surrealists, Pierre Loeb, Viot and the American writer Hemingway came to see me. Hemingway bought *The Farm*. At rue Blomet I painted the *Harlequin's Carnival* and the *Spanish Dancer*, now in the Gaffé collection. For all that I began to sell work then, things were very hard. I did many drawings for *Harlequin's Carnival*

7

where I used the hallucinations that had been brought on by my hunger. I would come home at night having eaten nothing all day and put my feelings down on paper. I spent a lot of time with poets that year because I thought it was necessary to go beyond the 'plastic fact' to achieve poetry.

Several months later, Jacques Viot organized my first exhibition at the Galerie Pierre. Afterwards I got a contract with Viot that helped me to keep going. I rented a studio at 22 rue Tourlaque, in the Villa des Fusains, where Toulouse-Lautrec and André Derain had lived and where Pierre Bonnard still has his studio. Paul Eluard, Max Ernst, a Belgian dealer from rue de Seine, Goemans, René Magritte and Arp were all living there at the time. I put a sign on my door that I had found in a shop: 'TRAIN PASSANT SANS ARRET' (Non-stopping train). Things had improved, but they were still quite tough. On one occasion, I shared a meal of radishes and butter with Arp. As soon as I could, I took a larger studio on the ground floor of the same villa, but I didn't keep it long.

I returned to Spain, got married, came back to Paris with my wife and left the Villa des Fusains, where I had painted the whole series of blue canvases, for an apartment on rue François Mouthon. I worked a lot and spent most of the year in Spain, where I could concentrate better on my work. In Barcelona, I worked in the room where I was born.

In Spain, where I went often, I never had a real studio. In the early days I worked in tiny cubicles where there was hardly enough space for me to get in. When I wasn't happy with my work I banged my head against the walls. My dream, when I am in a position to settle down somewhere, is to have a very large studio, not for reasons of brightness, northern light, etc … which I don't care about, but so that I can have space, lots of canvases, because the more I work the more I want to work. I would like to try my hand at sculpture, pottery, engraving, have a press.

8

Also to try, as far as it's possible, to go beyond easel painting, which in my opinion has a mean enough goal, and to bring myself closer, through painting, to the human masses whom I have never stopped dreaming of.

At the moment I find myself living on boulevard Blanqui, in the same house as the architect Nelson. It was here that Mrs Hemingway kept *The Farm* before taking it to America.

Once I was taken with the desire to go back and see the studio on rue Blomet. There was a very beautiful lilac bush in the courtyard. The building was being demolished. A big dog jumped on me.

JOAN MIRO, 'Je rêve d'un grand atelier',
published in XX^e *siècle*, Paris, May 1938. © Fundació Miró.

Miró – A Close-Up View

these photographs by Jean-Marie del Moral allow us a glimpse of the studio in Palma, Majorca, into which Joan Miró moved in 1956 and in which he worked continuously until a few years before his death on 25 December 1983. Not many photographers were given the opportunity of photographing Miró in his studio, because the artist could not endure the presence of strangers in his working quarters. The pictures bear witness to Miró's complex, dazzling efforts: like a scribe in a monastery, he surrounded himself with all the equipment he needed to keep his emotions at fever pitch so that he could work day after day, without interruption.

He would have appreciated the non-chronological approach of this book; it reflects the complicity that exists between a painter and his work, the work scattered all over his studio, with different items which are all continually vying for the attention of their creator like a roomful of small animals.

'I paint what I am,' declared Miró one day, with reference to his own taciturn, over-sensitive and melancholic temperament.[1] His paintings reproduce perceptions and objects which, having been submitted to a process of transformation and metamorphosis, have assumed the new identity attached to them by the artist. This process occurs automatically and/or subconsciously.

Still vivid in my memory are the afternoons when Miró used to sit on the sofa after lunch making pencil drawings with a firm hand, releasing a torrent of energy. He always drew with his paper supported on a hard surface, otherwise the very sharp point of the pencil would have made a hole in the paper. 'My painting bears no resemblance to a private journal. It is an irresistible compulsion that manifests itself externally,' he said in 1978.[2] This necessity to reveal the irresistible compulsion externally undoubtedly helped him to battle on and, finally, to continue to live.

I had the good fortune to spend my childhood with him and, although I was only fifteen when he died, I was well aware that those around him treated him with respect and a kind of veneration. I found it difficult to apprehend the difference between the grandfather-figure who lived at Génova[3] and the artist of genius as he was perceived by the general public. The moments I spent in his company were the most precious, and Miró was delighted by the childish innocence of the ten-year-old boy whose sole aim was to have fun with him. An evening walk together in his garden was the best way of entering his world; he used to teach me how to listen to the silence, how to look at things in the dark, how to communicate without words. His blue eyes, in which could be read the avidity and lightness of his soul, transmitted this intangible poetry. He used to compare himself to the carob tree: 'The worse I feel, the more eagerly I proceed. I am like the carob tree whose roots are very deep and which will not be flattened by weeks of rain or storms.'[4]

m iró's creative urge was all-consuming and always on the alert. Throughout his life he was obsessed with freedom of expression, made manifest in a plastic and iconographic idiom that could be understood by all, but which he alone was capable of producing. 'I never dream when I am asleep, I only dream when I am not asleep,'[5] said Miró, explaining thus why he was so easily seduced by a landscape, and why, in conversation, he was able immediately to grasp subtleties that would escape his more intellectual companions. Evidently, Miró's sensibility was unadulterated.

He was in the habit of rising very early, having breakfast and then going down to the Sert studio where he would work until Pilar fetched him for lunch. During lunch Miró was frequently abstracted: his attention might, for instance, be caught by a seductive shape that he would later use in one of his paintings. In the afternoon he would sit in his favourite armchair and produce dozens of rough sketches for future projects. When he was tired he would go up to his study to listen to classical music or read poetry. I remember that my brothers and I would sometimes mislay things like balls, hats, puppets – small items that we would find years later coated in bronze or incorporated into one of his sculptures!

The world created by Miró had enormous imaginative strength. It was fundamentally linked to elements that were very humdrum or alternatively very poetic. This was possible thanks to the complicity inherent in his work between free poetic association and his own acute visual sensitivity.

Miró and the Sert Studio

the studio was built in 1956, under the direction of Josep Lluis Sert, a great friend of Miró and also a great architect who designed (amongst other things) the Spanish Republican pavilion in Paris in 1937, the Fondation Maeght in St-Paul-de-Vence in 1964 and the Miró Foundation in Barcelona in 1975. Pilar was responsible for commissioning the project because Miró would never have dared to bother his friend, who was teaching architecture at Oxford at the time. Miró was delighted, however, when he learned that Sert had accepted the commission.

The studio always struck me as being a light-hearted, Mediterranean type of building, because of its brilliant white walls and its long roofs in the shape of 'seagulls' wings'. I used to climb on the roof when I wanted to hide from my grandparents. The space was adapted to Miró's requirements. Now, at last, when he was sixty-three, his dream had come true: a big studio! Sert was obviously familiar with the principles of the celebrated American architect Louis Sullivan (1856–1924), the teacher of Frank Lloyd Wright, who contended that 'the form of a building must always follow its function.'[6] He designed an extremely functional building that fitted Miró like a glove.

for the artist the space had religious significance. It was a place for meditation, solitude and creation. The only sounds were his breathing and the creaking of his rocking chair when he sat down to

think. Miró concentrated very intensely when he was working, lying in wait for the slightest incident, the spark that would lead him towards new perspectives, towards the creation of the tangle of signs that would translate arbitrarily into poetic language, or into musical-chromatic composition. In the 1970s, Miró finally admitted that he was working 'in a second state, with unfettered violence, so that people should see that he was still alive and that he was still moving towards new horizons'.[7]

In 1973 Miró spent several days working on a farm near Tarragona where, in collaboration with his friend Josep Royo and in the unobtrusive presence of the photographer Francesc Català-Roca, he created the series of 'Burnt Canvases'. Català-Roca's photographic record of the event shows Miró burning his canvases with petrol while controlling the process with a broom dipped in water and with his own shoes – he is seen trampling on the spots where the fire is progressing too fast. After the burning, Miró applied different colours to the damaged surfaces and then sent the canvases to his studio in Majorca, where he added the finishing touches. Creating works such as these confirmed the 'aggressive power, the pure violence' of a youthful eighty-year-old. 'A while ago I burnt some canvases,' said Miró. 'I burnt them for artistic and professional reasons and the results were very beautiful; I also burnt them in order to cock a snook at people who say that these canvases are worth a fortune ... I'm sorry to say that people do not see canvases, they only see dollars.'[8]

many of Miró's largest paintings date from the period of the Sert studio: *Blue I*, *Blue II* and *Blue III*, painted on 4 March 1961; the *Mural Painting for the Cell of a Solitary Man*, in 1968, as well as the tragically celebrated *Triptych to the Hope of a Condemned Man*, in 1974, painted in memory of the young Catalan anarchist condemned on Franco's orders to death by garotting. Miró recalled how 'some years ago I painted a small white line on a large canvas, and on another a small blue line. Later the time was ripe ... just at the moment when that poor young man, Salvador Puig Antich, the Catalan, was garotted. I felt sure that that was what was happening ... I finished the painting on the day he was murdered. Without being aware of it.'[9]

13

The Sert studio offered Miró the working environment that he needed. When he closed the door he knew that he was shutting himself away from all contact with the outside world and entering the private world of his imagination. This private world, Miró's reality, was filled with Mediterranean light, forms and colours.

Miró and his Possessions

the images and objects collected by Miró in the Sert studio constituted the fragments of his future chamber music: they were the accessories from which he would create works more elaborate than his traditional images of the sun, a bird, the moon. At the outset he would make a collection of unusual items, strange and unexpected objects that, when removed from their normal context and gathered into a homogeneous group, would open a rich and fertile seam of possibilities, propitious to impulsive digressions.

Miró was particularly attracted to old and battered objects that had been abandoned as 'of no further use'. When walking on the beach or in the hills he would indulge this attraction. He liked to stand on the cliff's edge and feel the breeze from the Mediterranean, or listen in solitude to the singing of the birds on the top of a hill. As he walked he would systematically pick up anything that caught his eye. Not at random, however: only things whose shape or particularity attracted his attention. In 1978 he explained that 'my present absorption in all these bits and pieces, in all these treasures, is quite new. I've been hypnotized. When I go for a walk I don't hunt for objects as if I were looking for mushrooms. There's a sudden force, bang! like a magnetic force that makes me look down at a certain moment.'[10]

His studio gradually filled up with shells, roots, empty cans, bones, pumpkins, pine cones, almonds, snail shells and bats' skeletons, amongst other things – and not forgetting his collection of traditional and folk art. 'Folk

art never fails to move me,' said Miró, 'because it is free of deception and artifice. It goes straight to the heart of things.'[11] This remark explains Miró's desire to stay close to nature and to popular art: both are unadulterated and removed from speculation; both possess a beauty that owes nothing to the manipulations of the art world.

Once he had gathered together a collection of different objects, Miró's intense interest would confer new meaning on the group; the process of observation now set in train would open up new perspectives and new ideas for transformations. As Breton observed: 'Experiment is not a matter of passive observation; it is the invention of a new kind of experience made possible by allowing reason to confirm what tactile experience might seem to deny.'[12]

Every object possessed magic or almost sacred properties, to which Miró gave a semi-religious significance. The *signifier* remained the same but the *signified* altered to place the object in a new context, a context marked by metaphor and by the distillation of intuition.

Miró and the Creative Process

I have described the importance of Miró's studio and of his collection of *objets trouvés* to his work, and it would be possible to spend a lifetime analysing the role played by each of these in his creative mythology.

As my brother David commented, however: 'For Miró the most important factors were his own reaction to his work, his self-discipline and his adherence to the highest standards – the last two testifying to his faultless honesty. He also maintained a constant development in his work and a provocative spirit that never left him.'[13]

When he was eighty-five, provocation and aggression were undoubtedly the spurs to his creative process. 'Yes, aggression ... Why this aggression? I do not know. But this has motivated me to work. I hope that people will do me the honour of attacking me until the day I die.'[14]

After he had made the difficult choice of what materials to use, Miró was faced with the task of transferring his personal sensations onto a solid base. A small stain on the canvas, a tear by the stretcher, a splash of paint on the floor or any other small incident could provoke a chain of events that would allow Miró to start work without further ado.

In the Sert studio there were innumerable preparatory sketches on all sorts of backgrounds: printed material, newspapers, the backs of letters, butcher's wrapping paper, bus tickets ... Ideas put down on the first piece of paper that came to hand, and then repeated much later as a point of departure.

When I analysed the colours used by Miró in his late work I realized that black was predominant and had become in fact the background colour to all his painting. 'I work in stages,' said Miró. 'First stage blacks, and then the rest, which is determined by the blacks ... If I apply a colour when the one before it is not yet dry, certain mixtures and nuances ensue.'[15]

When the painting was dry he would stand it in a corner of the studio where he could go on analysing it and comparing it with the rest. Because he never underestimated the importance of improvisation, he found it very difficult to finish a painting. Although he worked alone he was surrounded by 'accomplices' who would insist that he innovate and repaint constantly, and that he take risks all the time. He explained: 'I began this painting two or three years ago and I realized that it did not really work. This preyed on my mind. Then it suddenly came to me that three strokes were missing. When I realized this I added the red at the side. Now it's good.'[16]

miró always sailed on uncharted waters and dared to criss-cross them in search of the unknown. His interior aggression and perseverance stimulated him to continue the search and provided material for the continuous development he needed. He was always on the look-out for problems or obstacles to

overcome. Towards the end of his life he became the victim of his most feared enemy, an enemy he had always sought to avoid – fame! 'I'd like to go out saying to hell with everything,'[17] he said as early as 1969, disgusted by the financial speculation surrounding his pictures, which by now represented sums of money almost worth quoting on the stock market. Miró devoted his whole life to the reassertion of artistic and spiritual liberty; even though he wanted to escape the cult of the artist he could not deny the strength and pragmatic nature of his own work.

<div align="right">Joan Punyet Miró, Palma, Majorca, 19 April 1996.</div>

Notes

1. Pierre Bourgier, 'Article (excerpts)', *Les Nouvelles littéraires*, Paris, 8 August 1968.
2. Georges Raillard, *Conversaciones con Miró*, Barcelona, 1978, p. 227.
3. Génova is a residential suburb about five kilometres from Palma. Joan Miró lived here with Pilar in a house named 'Son Abrines'. To get to the Sert studio he had to go down a flight of steps. His print-making studio was on the other side of a clump of pines, in a large seventeenth-century Majorcan house named 'Son Boter'.
4. Georges Raillard, *Conversaciones con Miró*, p. 230.
5. David Fernandez Miró, 'La Santa Inquietud frente al Mar', *El Pais*, Madrid, 1981. Cultural supplement.
6. H.W Janson, *History of Art*, London, 1995, p. 753.
7. Santiago Amón, 'Tres horas con Joan Miró', *El Pais Semanal*, Madrid, 1978.
8. Georges Raillard, *Conversaciones con Miró*, pp. 32–33.
9. Ibid., p. 54.
10. Ibid., p. 187.
11. Catalogue to the exhibition *Joan Miró: L'Arrel i l'Indret*, Barcelona, 1983, p. 43.
12. Paul Feyerabend, *Against Method: Outline of an Anarchistic Theory of Knowledge*, London, 1979, p. 92.
13. David Fernandez Miró, 'Cerca de Miró', *La Vanguardia*, Barcelona, 14 May 1991. Cultural supplement.
14. Georges Raillard, *Conversaciones con Miró*, p. 33.
15. Yvon Taillandier, 'Miró: "Now I Work on the Floor"', *XXᵉ siècle*, Paris, 30 May 1974.
16. Georges Raillard: *Conversaciones con Miró*, p. 123.
17. Guide to the Pilar and Joan Miró Foundation, Palma, Majorca, 1992, p. 78.

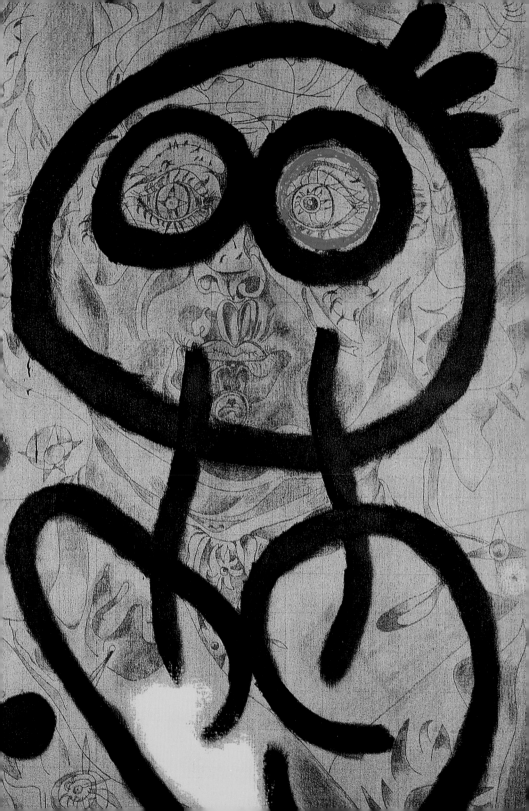

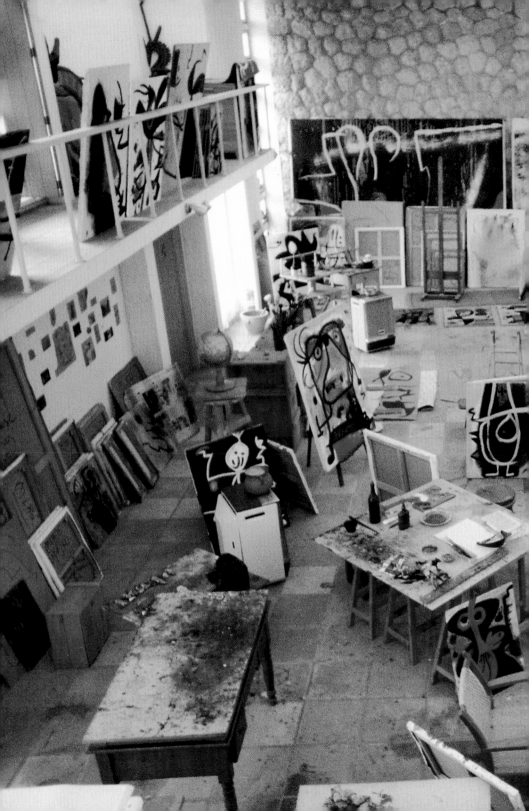

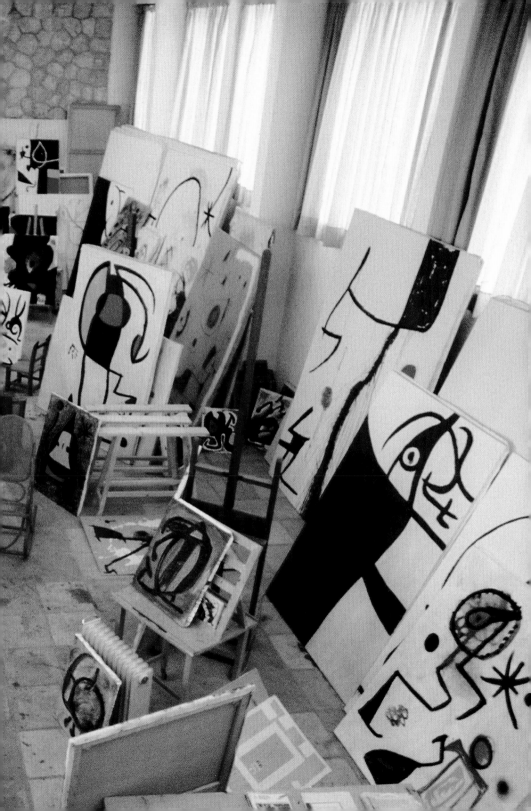

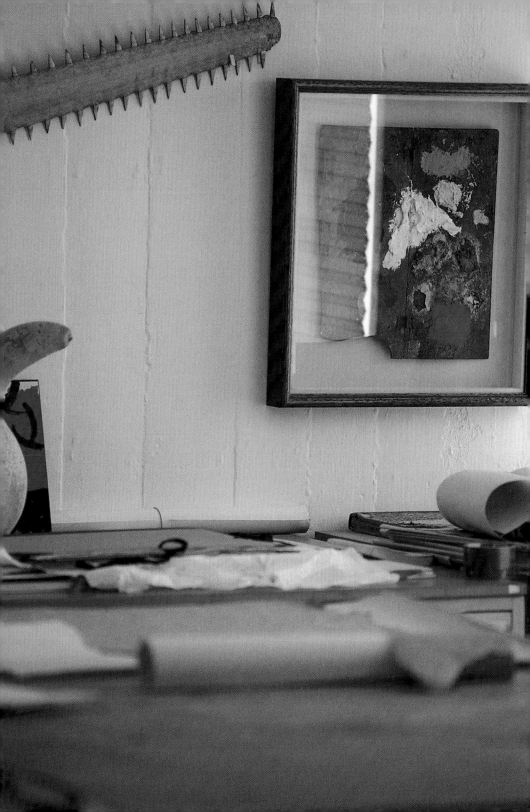

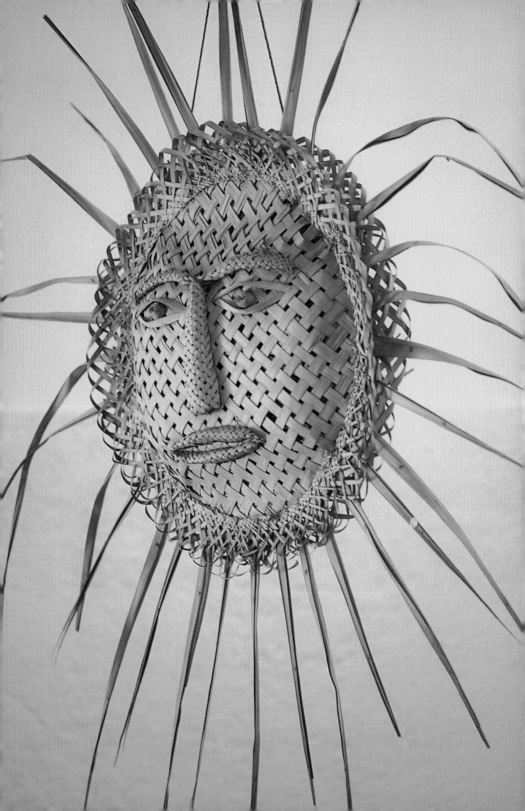

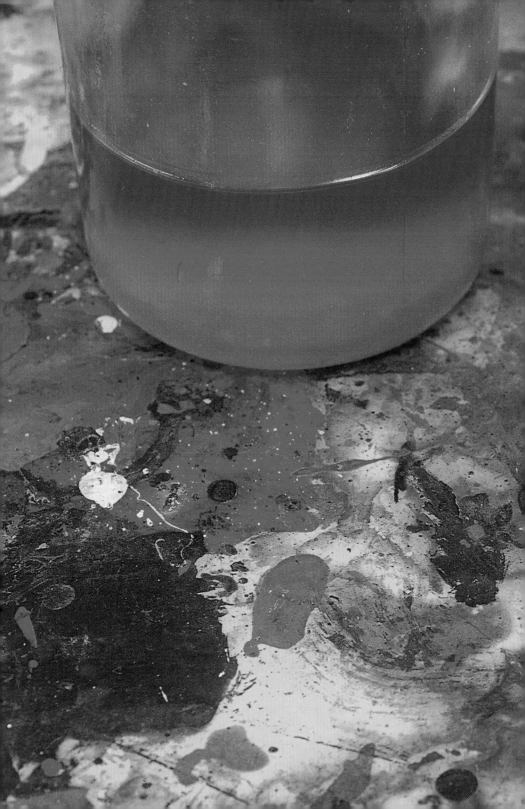

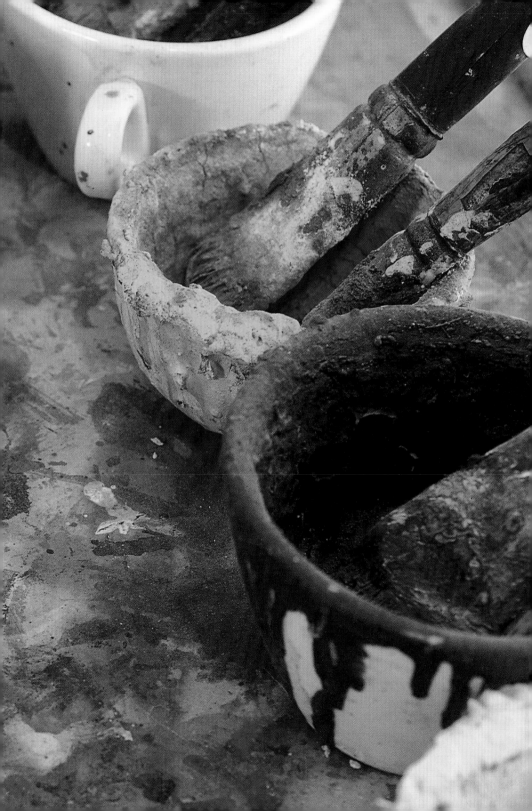

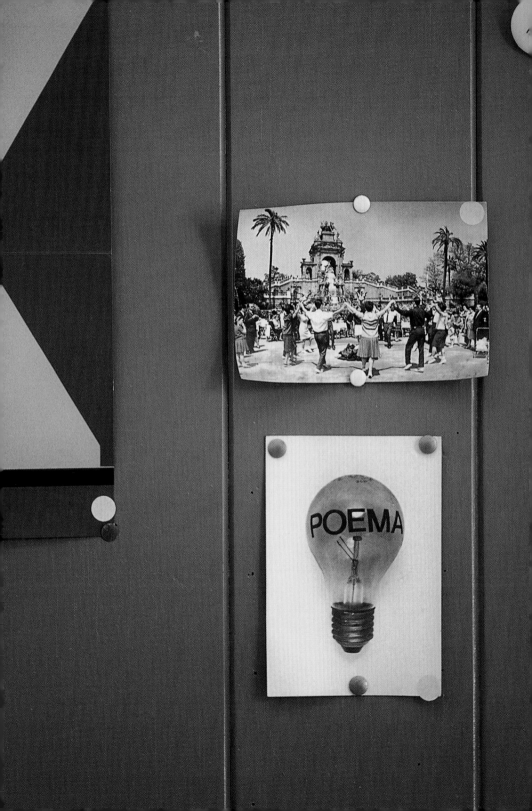

JOAN MIRÓ

l'été

Une femme brûlée par les
flammes du soleil attrape un papillon qui s'
envole poussé par le souffle d'une fourmi se
réposant à l'ombre arc-en-ciel
du ventre de la femme devant la mer
les aiguilles de ses seins tournées vers
les vagues qui envoient un sourire blanc
rose au Croissant de la lune

3695

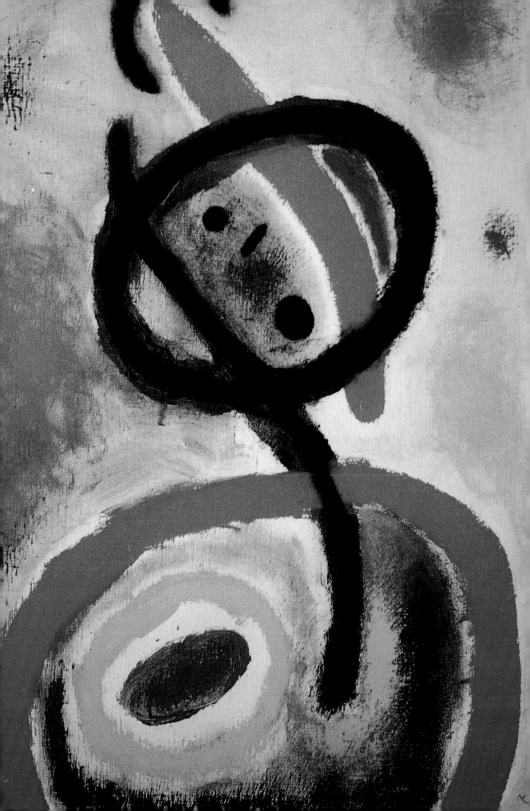

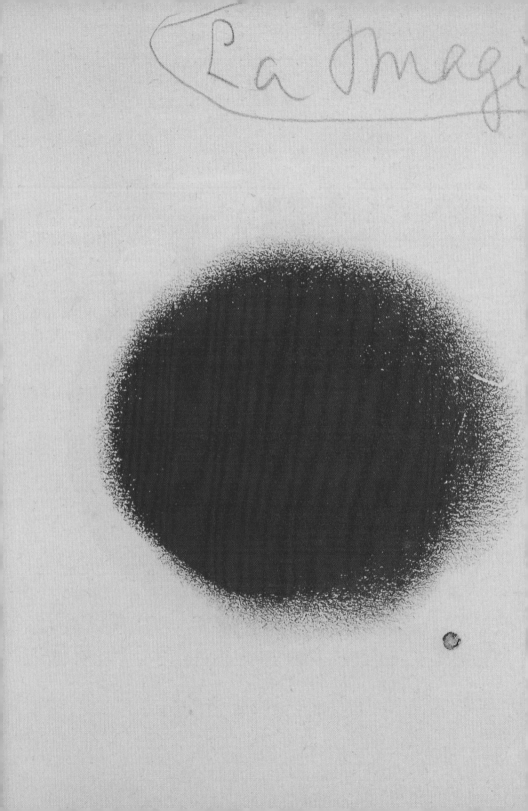

de la Couleur

fét amb m
diep

(grantil)

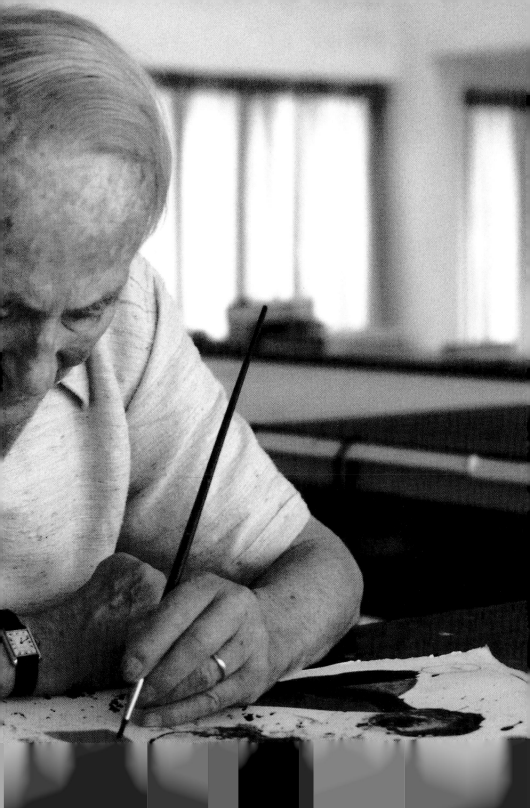

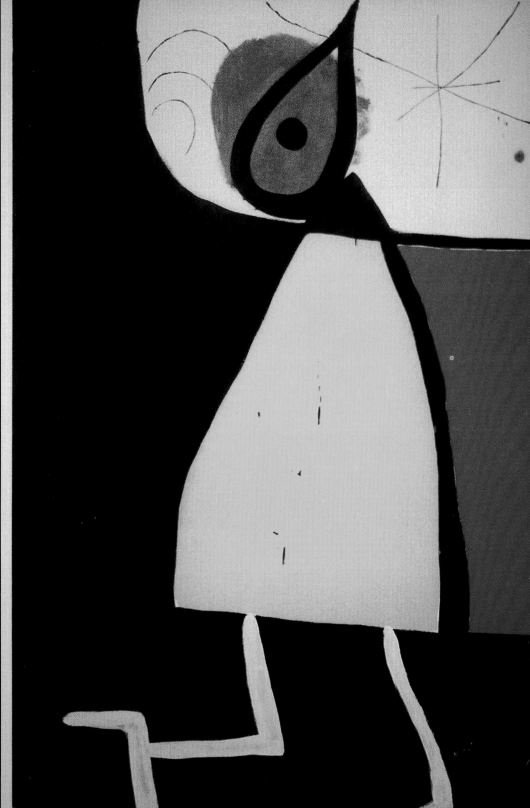

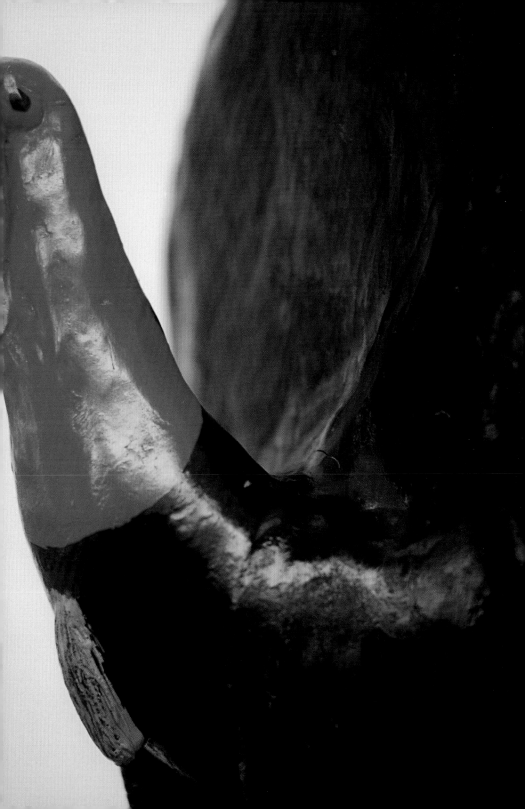

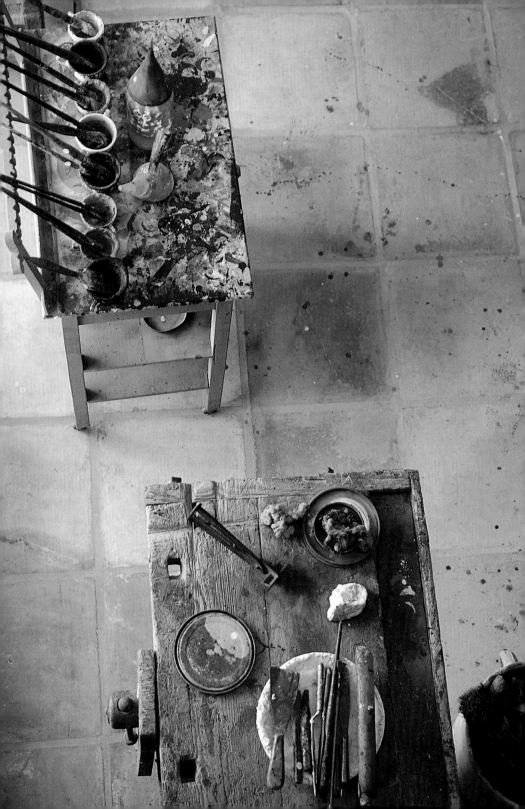

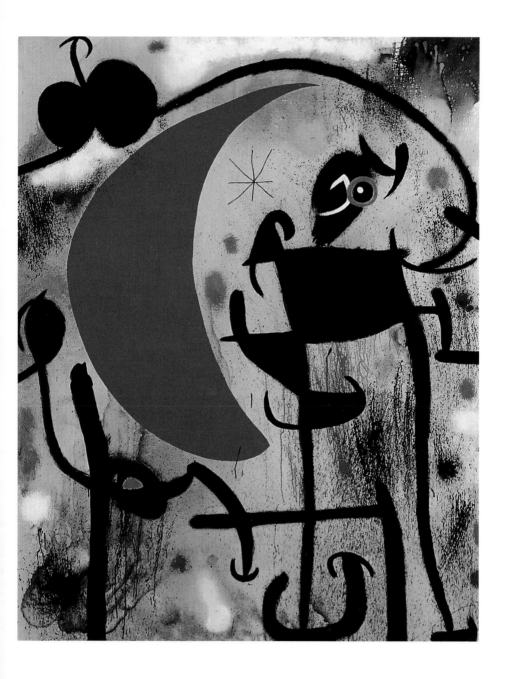

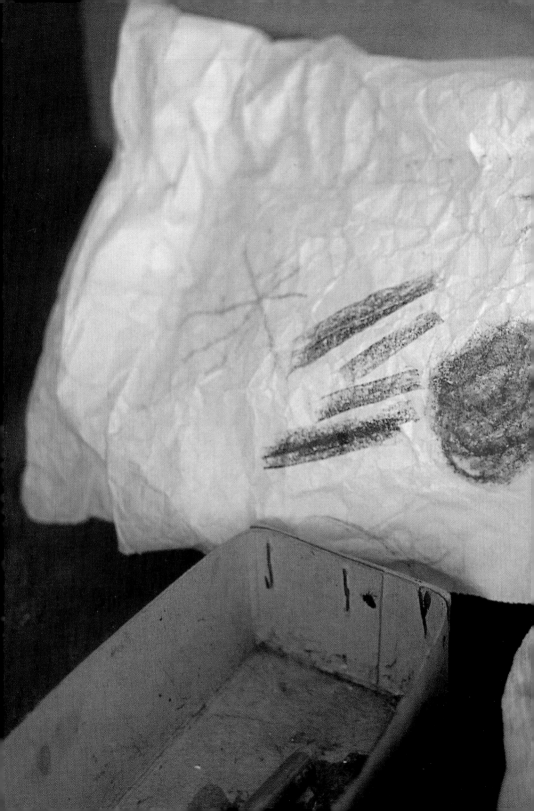

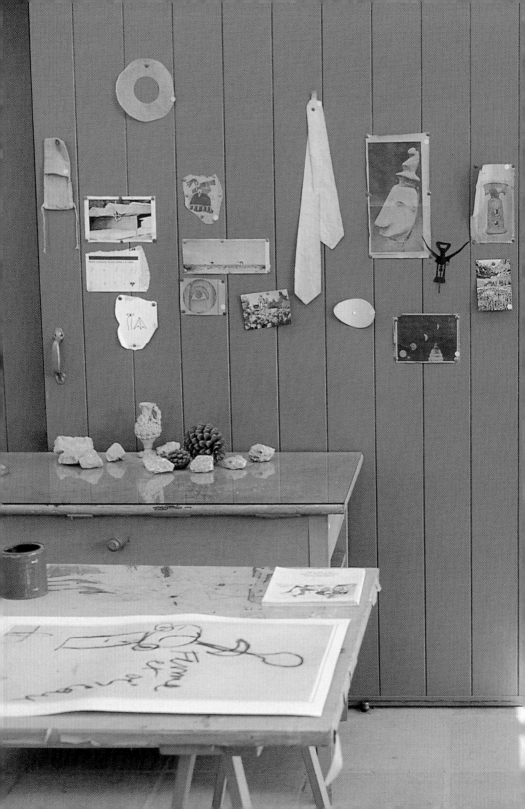

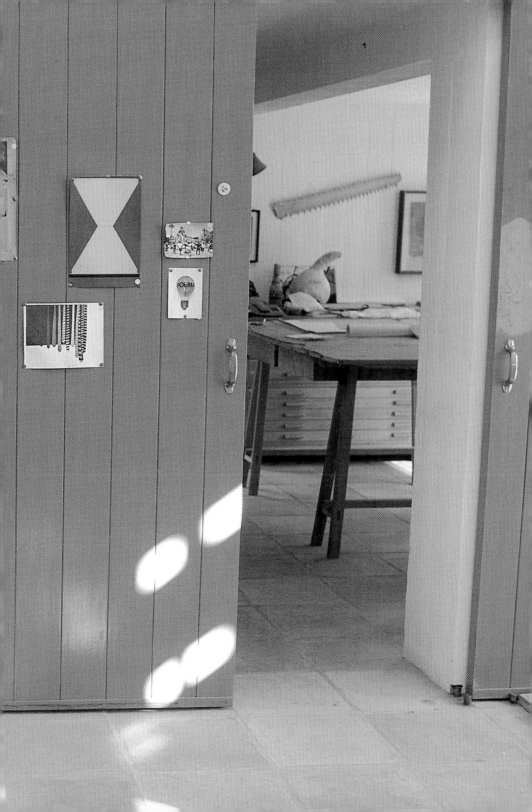

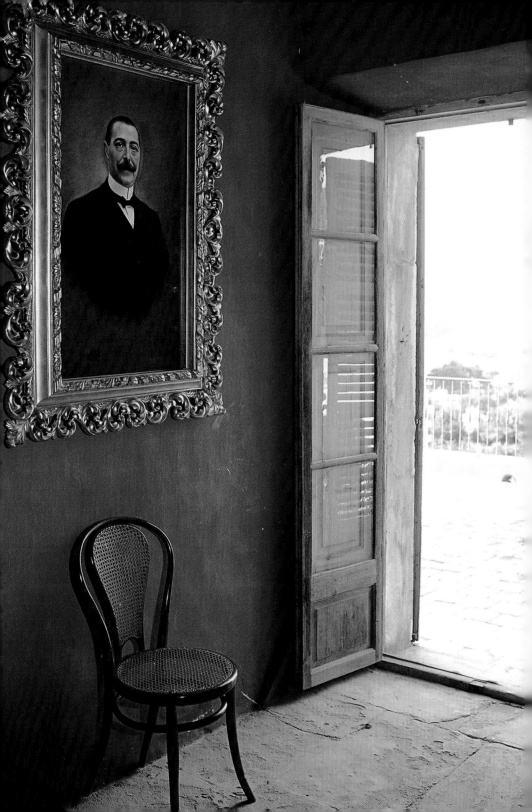

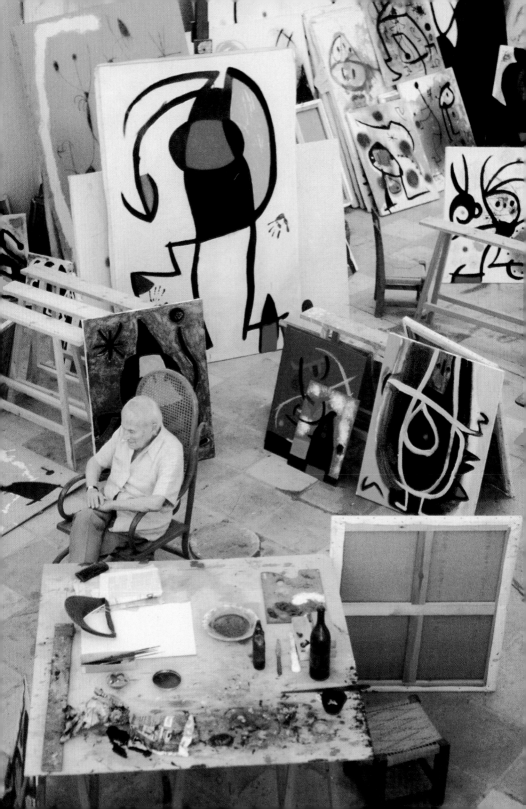

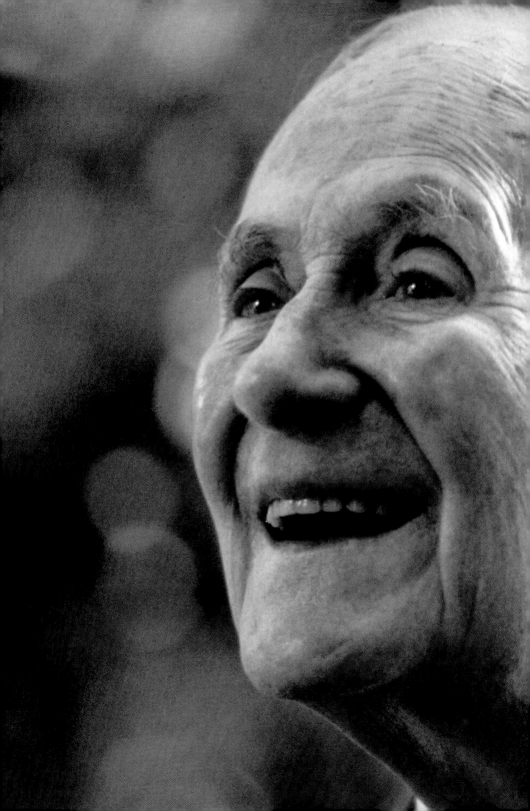

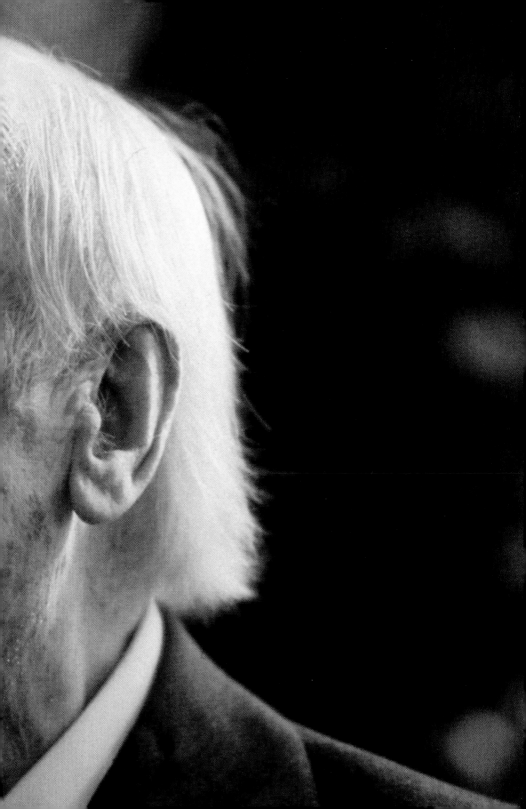

Cet album, quatorzième de la collection "Las Estampas de
La Cometa", comporte cinq eaux-fortes originales en couleurs
de Joan Miró et cinq poèmes tirés sur feuilles à part de Salvat
Papasseit.

Papier Arches
Format des cuivres et du papier 90 x 63 cm.

Les eaux-fortes originales ont été tirées à la main dans l'atelier
de l'éditeur, sous la direction de Joan Barbarà.
Le tirage a été limité à:

50 exemplaires numérotés 1/50 à 50/50, signé par l'artiste.
5 exemplaires d'épreuves d'artiste, numérotés P. A. 1 à P. A. 5.
15 exemplaires "hors commerce", réservés aux collaborateurs,
numérotés du I à XV.
Toutes ces épreuves ont été signées par Joan Miró.
Il a été tiré à part trois exemplaires marqués a, b, c, non signés,
réservés aux dépôts légaux.

Après le tirage tous les cuivres, dûment rayés, ont été donnés
au "Centre d'Estudis d'Art Contemporani Joan Miró", de
Barcelone.

Achevé d'imprimer en février mille neuf cents soixante-quatorze.

Etui en toile illustré d'un dessin de l'artiste.

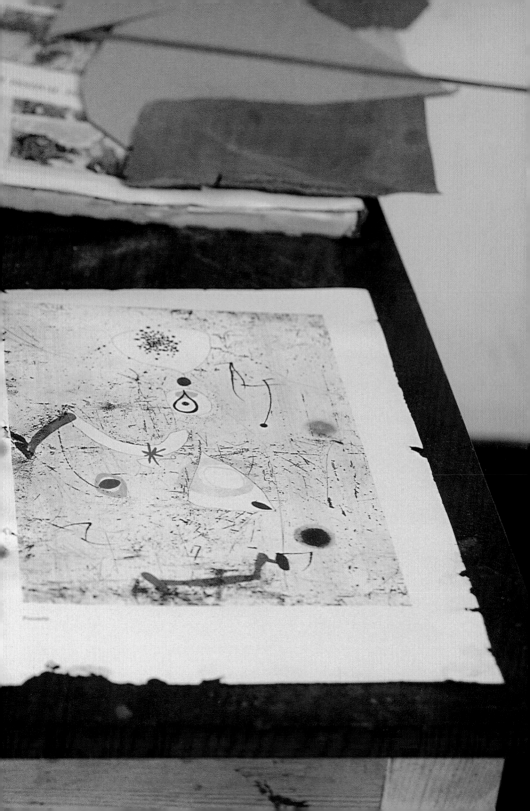

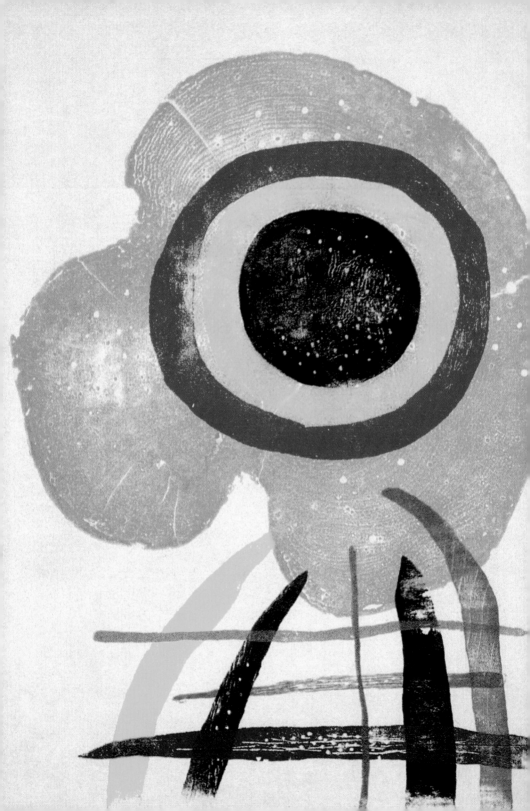

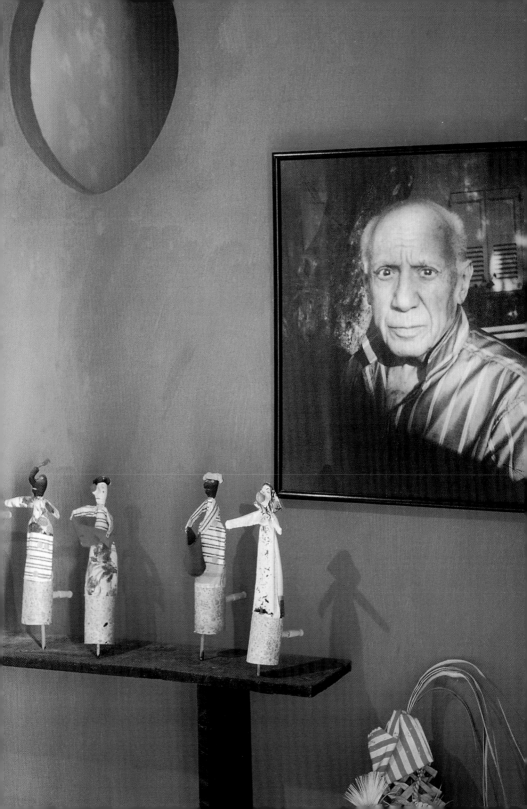

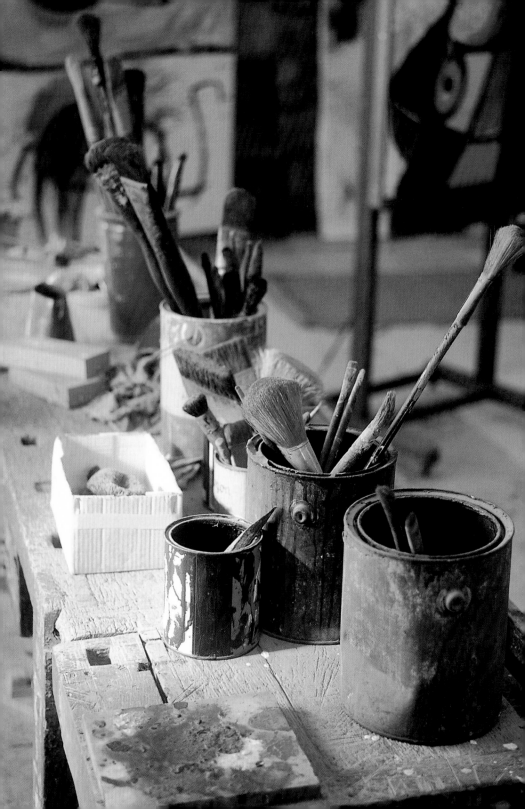

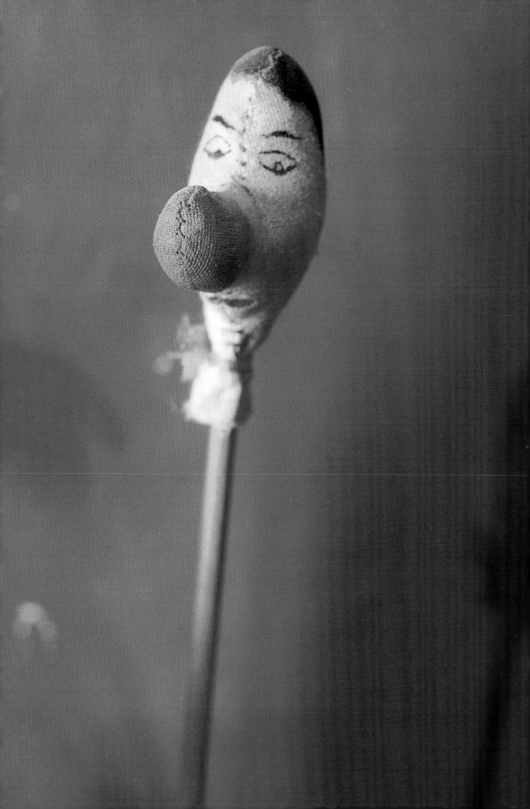

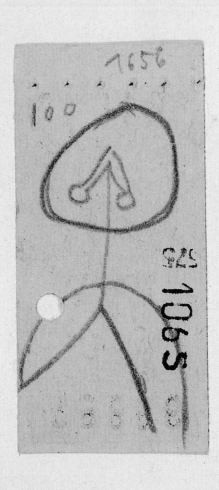

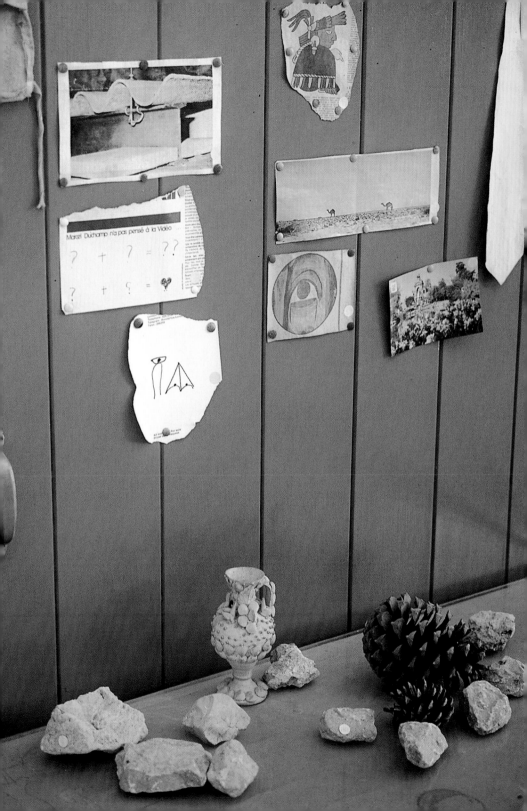

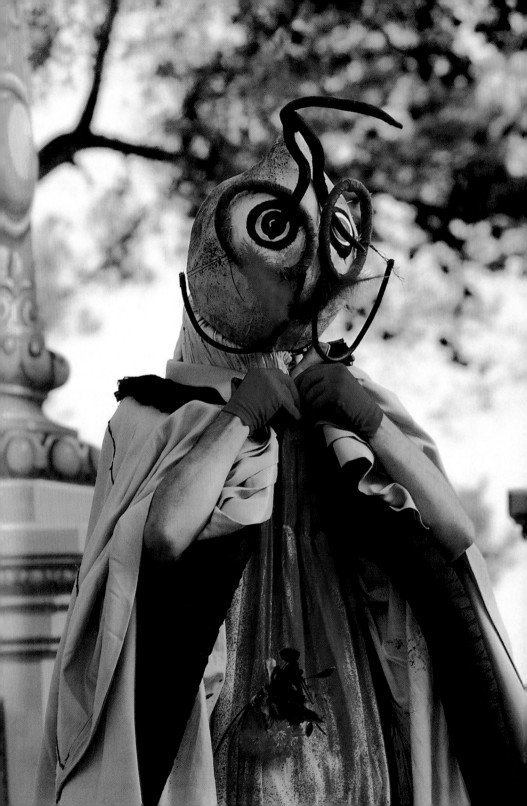

TETE DE FEMME EN IVOIRE (3500-3100 av. J.-C.)

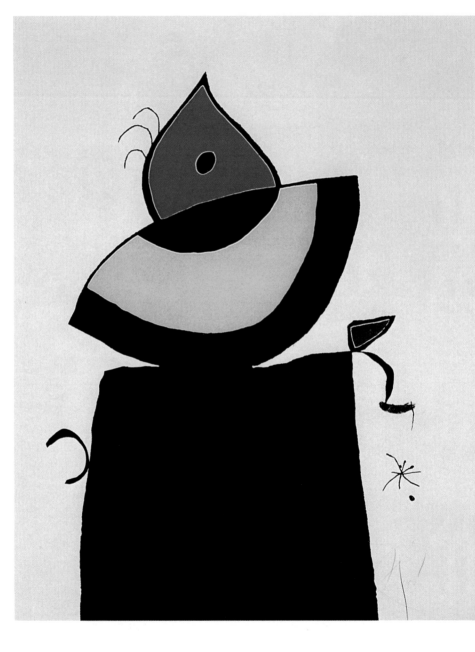

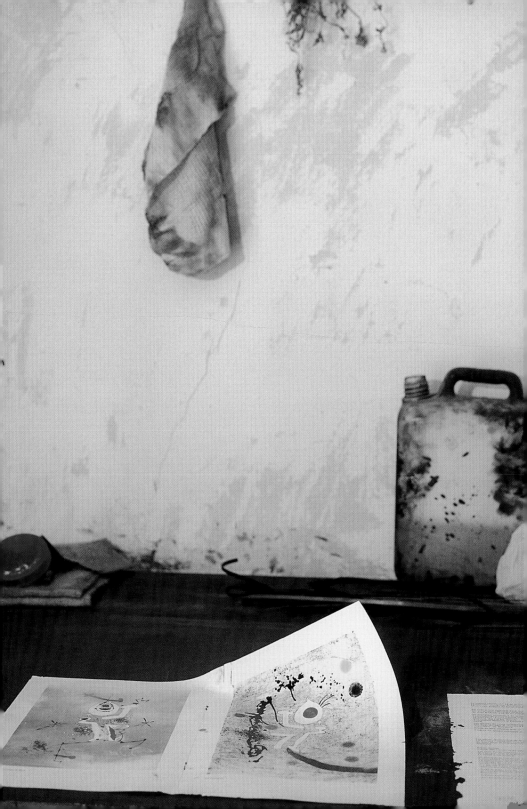

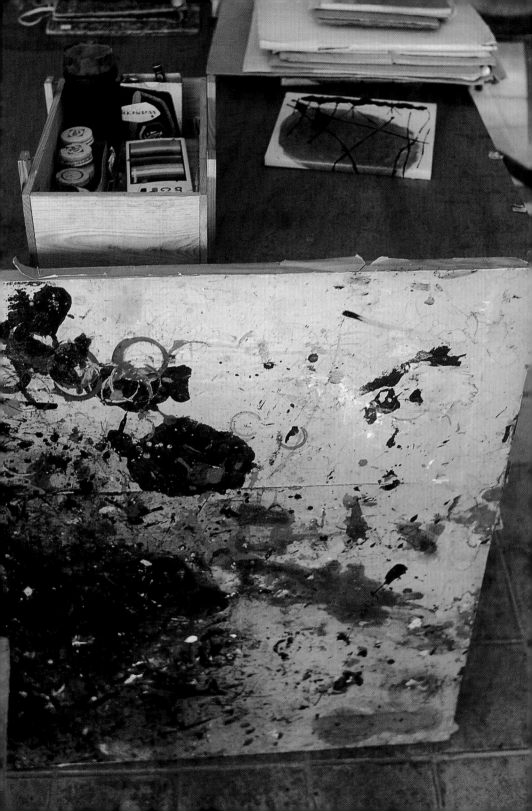

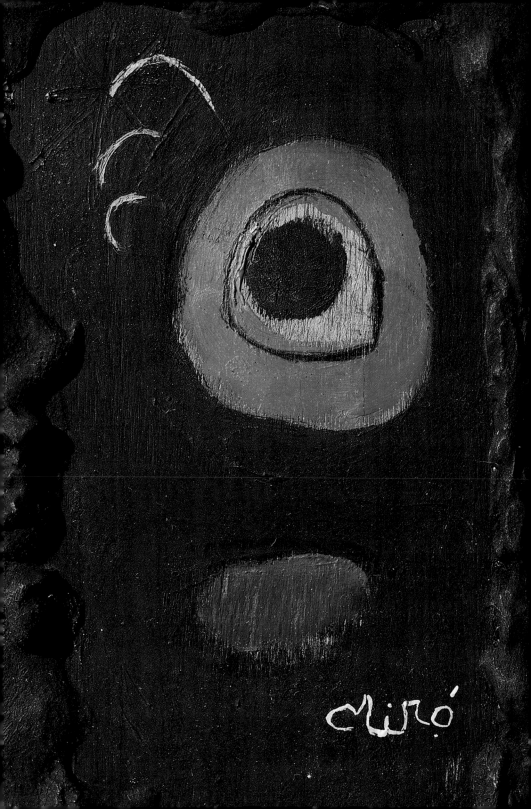

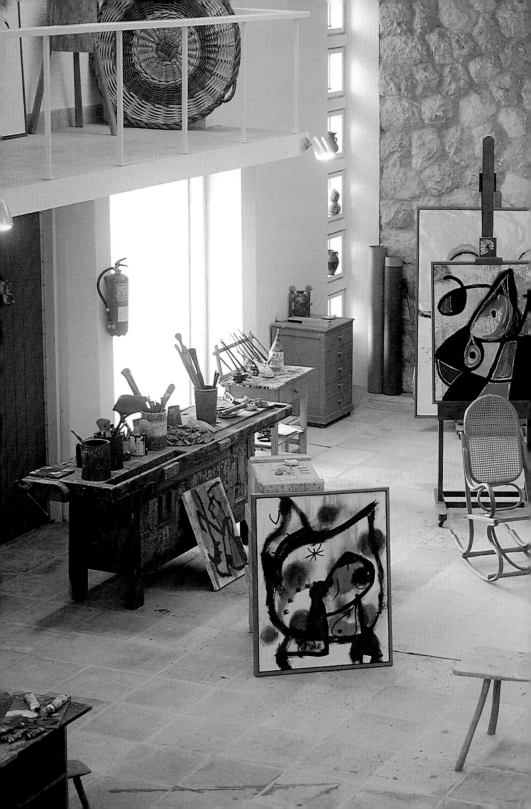

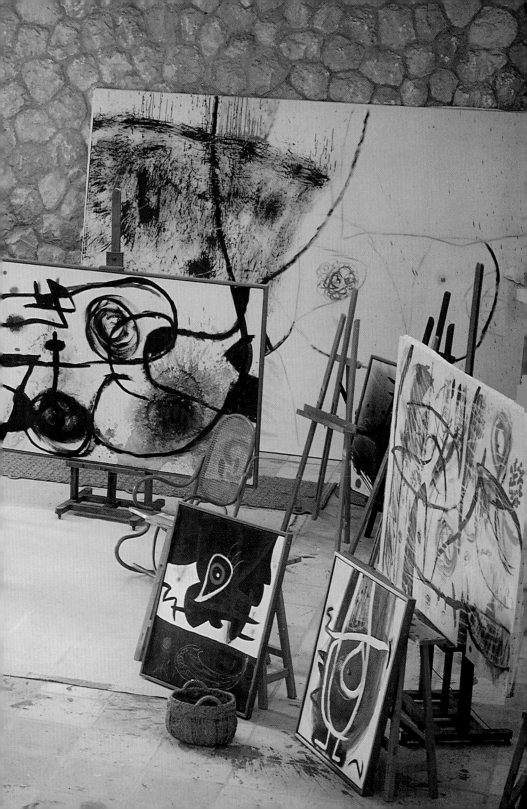

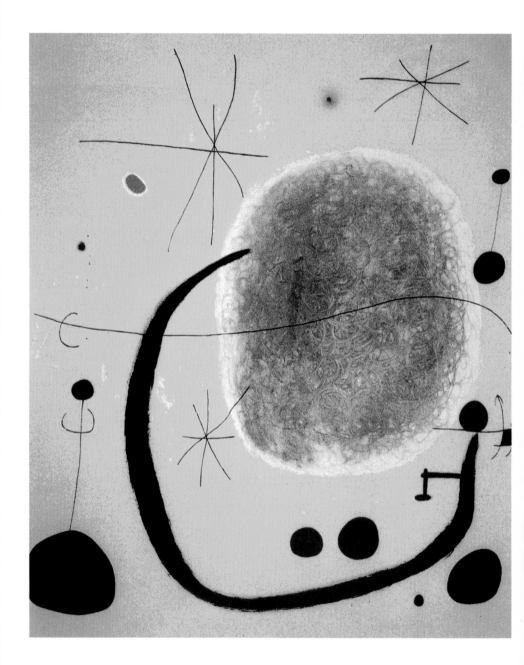

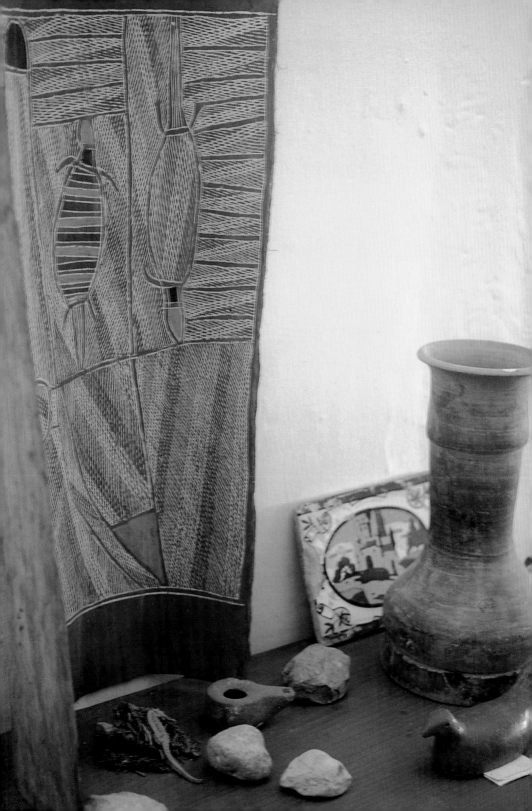

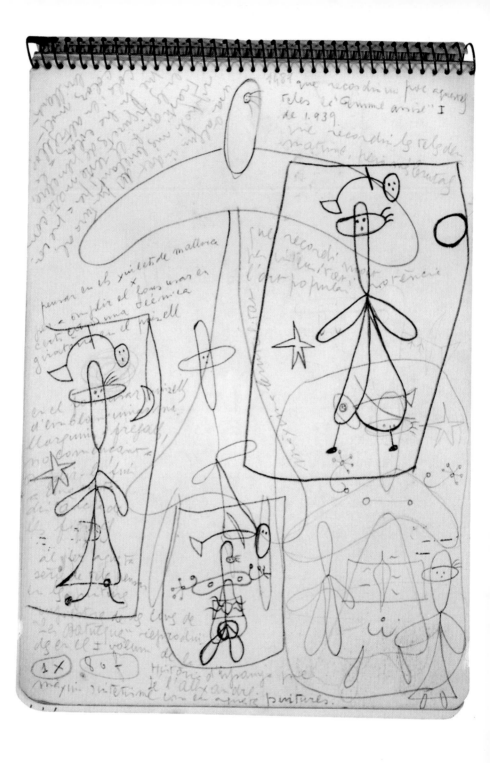

Miró in his Studio

'I will make my work *emerge* naturally, like the song of a bird or the music of Mozart, with no apparent effort, but thought out at length and worked out from within.' *From Miró's working notes, 1941–42.*
Self-Portrait. Started in Paris in 1937, this self-portrait was completed in Miró's studio in Palma, Majorca, in 1960.

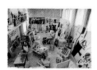

'For this reason I always work on several canvases at once. I start a canvas without a thought of what it may eventually become. I put it aside after the first fire has abated. I may not look at it again for months.' *Interview with James Johnson Sweeney, 1948.*

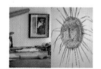

'... gazing at a beautiful woman, reading a book or listening to a concert will suggest visions of forms, rhythms, and colors which will shape and nourish my spirit so that its voice will be stronger.' *Letter to E.C. Ricart, 1916.*
'The weather here is wonderful, with a summerlike sun; this allows me to work a great deal.' *Letter to E.C. Ricart, 1918.*

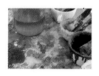

'Even a few casual wipes of my brush in cleaning it may suggest the beginning of a picture.' *Interview with James Johnson Sweeney, 1948.*

'I have not worked any more on my drawing-poems or poem-drawings. No doubt I will return to this means of expression later; once I have several of them, they should be published as a book-object.' *Letter to Pierre Matisse, 1937.*
Summer, 1937. India ink on paper.

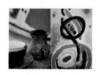

'A saucer made by peasants, a bowl for eating soup – for me, these things are just as wonderful as a Japanese porcelain that you find in museums.' *Interview with Georges Charbonnier, 1951.*
Woman III, 1965. Oil on canvas.

'Melt down the metal of my empty paint tubes and use the resulting shapes as my starting point.' *From Miró's working notes, 1941–42.*

The Magic of Colour. Preparatory drawing for *Painting*, 1930. Pencil und gouache on paper.

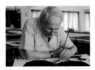

'Doing color etchings is a dead thing. – do them the way they used to be done, engraved in black and colored by hand. *From Miró's working notes, 1941–42.*

Woman in the Night, 1973. Acrylic on canvas.
Plaster Turkey, painted in the colours Miró liked best: red and black. 'Folk art always moves me ... It surprises, and is so rich with possibilities.' *Interview with Yvon Taillandier, 1959.*

The painter's palette-table and his equipment on a carpenter's bench.
Woman and Bird in the Night, 1967. Oil on canvas. Collection Adrien Maeght .

'Keep a blank sheet of paper for trying out pencils of different numbers and then take the little bits of lead you get from sharpening the pencils, crush them into the paper and start from there.' *From Miró's working notes, 1941–42.*

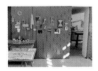

'Use things found by divine chance: bits of metal, stone, etc. ... That is the only thing – this magic spark – that counts in art. I must have a point of departure, even if it is only a grain of dust or a flash of light.' *From Miró's working notes, 1941–42.* Miró used to spend long periods contemplating this wall.

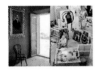

'My father was very realistic ... When I went hunting with him, if I said the sky was purple, he made fun of me, which threw me into a rage.' *Letter to Jacques Dupin, 1959.* Portrait of Miró's father.
'Be very disciplined about work, but also spend hours and hours in meditation and contemplation, the food of the soul.' *From Miró's working notes, 1941–42.*

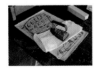

Project for a poster sketched on the page of a newspaper. *Free*, written in Catalan ('Llivres').

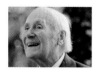

Miró on the day of his eighty-fifth birthday in Barcelona, 1978.

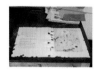

'I provoke accidents, a form, a spot of color. Any accident is good.' *Interview with Georges Charbonnier, 1951.*

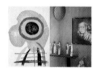

Engraving for *A toute épreuve* by Paul Eluard, 1958.
Miró and Picasso admired each other warmly and were firm friends all their lives. In front of the portrait of Picasso the collection of anonymous folk-art puppets sets up a magnificent dialogue with Miró's pictorial imagination.

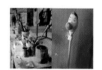

'If I don't paint, I worry, I become very depressed, I fret and become gloomy, I get "black ideas" and I don't know what to do with myself.' *Interview with Francis Lee, 1947–48.*
'Three forms which have become obsessions with me ... a red circle, the moon, and a star.' *Interview with James Johnson Sweeney, 1948.*

Miró loved this old carpenter's bench from his grandfather's workshop. 'I know that my maternal grandfather was very fond of me. Starting as a simple cabinet-maker's assistant, he finally had his own business. He could not read or write and he only spoke the Majorquin dialect.' *Letter to Jacques Dupin, 1957.*

Pencil on a metro ticket. 'I've been doodling all my life.' Interview with Francesc Trabal, 1928. Preparatory drawing for *Portrait II*, 1938.
'Publish an album with beautiful photos of objects I have found ... with a poetic text or poem, or better still, one of my own poems, if possible.' *From Miró's working notes, 1941–42.*

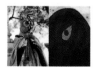

Marionette painted by Miró for the play *Mori el Merma*. The first performance was held in 1978 in Barcelona, and in the following year it was performed at the Fondation Maeght in St-Paul-de-Vence.
Head, 1940–74. Acrylic on canvas.

'[Each person travels with his own light, and] wherever you are, you can find the sun, a blade of grass, the spirals of the butterfly ... But in order to understand [them], we have to recover the religious and magical sense of things that belong to primitive peoples.' *Interview with Georges Duthuit, 1936.*
Project for a ballet, 1935. Pencil, gouache, pastels and collage on paper.

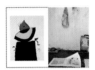

Etching for *Quatre couleurs accouchent le monde* by J.V. Foix, 1974.
'How do you store etchings so that the paper doesn't fox? In an open cupboard so the air circulates and keeps the humidity out.' *From Miró's working notes, 1941–42.*

'I feel deeply in harmony with the Japanese soul. Why?' *Interview with Pierre Bourcier, 1968.*

Miró always marvelled at the blots that formed on the paper where he cleaned his brushes and stood his paint-pots.
Painting, 1973. Oil on wood.

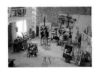

'It is difficult for me to talk about my painting, since it is always born in a state of hallucination, brought on by some jolt or other – whether objective or subjective – which I am not in the least responsible for.' *Statement in 'Minotaure', 1933.*

The Gold of the Azure, 1967. Acrylic on canvas.
'I'm only interested in anonymous art.' *Interview with Francisco Melgar, 1931.*

Study for Composition, 1934–41. Pencil and coloured pencils on paper.
'I feel myself attracted by a *magnetic* force toward an object, and then I feel myself being drawn toward another object which is added to the first, and their combination creates a poetic shock.' *Letter to Pierre Matisse, 1936.*

All the quotations are from *Joan Miró: Selected Writings and Interviews*, edited by Margit Rowell. Thames and Hudson, 1987.